R M Schindler

The Gingold Commissions

foreword by Peter Loughrey

with essays by Thomas S. Hines
 Gerard O'Brien
 Michael Boyd
 Mark Lee

William Stout Publishers

Foreword
Peter Loughrey

Never before have thirty pieces of Rudolph Schindler's furniture surfaced. Indeed, outside of the University Art Collection at the University of California, Santa Barbara, there are hardly thirty pieces of Schindler furniture anywhere in one location. When Gerard O'Brien, Michael Boyd and I first met to discuss this collection, we tried to put it in historical perspective. None of us could recall any large Schindler collections in private hands. It was with this realization that we all knew this collection deserved a thorough examination. Gerard immediately started interviewing Gingold family members and researching Schindler's archives while Michael began an analytical essay and enlisted the support of Thomas Hines and Mark Lee. Our purpose from the beginning was to honor the material, celebrate Basia Gingold and share our enthusiasm of Schindler's unique brand of architecture. With this catalogue of the collection and the accompanying exhibition, we extend an invitation for you to experience this exceptional opportunity as we have done.

Gerard, Michael and I would like to thank everyone who helped make this production possible; especially Gary Keith for his efforts early on with research and co-ordination. Basia Gingold's family; Joyce Sloan, Eva Bluestein, Claudia Cohan for numerous answers to as many questions. The University Art Collection at the University of California, Santa Barbara, and the Getty Research Center for opening their archives. And a very special thanks to our patient and supportive wives - Susan, Gabrielle, and Shannon- who allowed us to miss dinners and work late nights to bring this project to completion.

The Gingold Commissions

contents

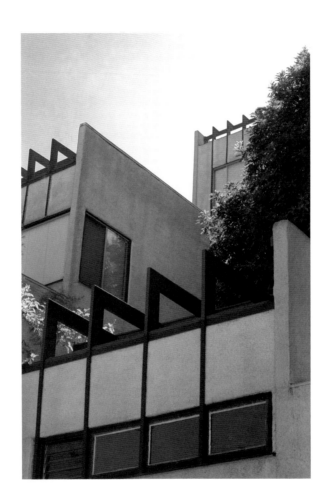

Manola Court apartments

The Gingold Commisions
And "The Architecture Touring Club"

Thomas Hines

In the best of times, vocations and avocations blur into each other, and professional relationships and personal friendships become indistinguishable. This has been the case with what I will call the "Architecture Touring Club," a four-person group that includes the architect, Mark Lee; the composer and designer, Michael Boyd; the art dealer and curator, Peter Loughrey - and myself. Each of us, along with gallery curator, Gerard O'Brien, now share the pleasure of contributing to this presentation of remarkable furniture from R.M. Schindler's Gingold Commisions. Other essays in this catalogue will explain its origins and character. Mark Lee, my UCLA colleague, and Peter Loughrey, a long-time acquaintance, introduced me to Michael Boyd, and the four of us have subsequently enjoyed periodic Saturdays together on determined, if highly flexible, treks through the varied landscapes of Southern California - observing and analyzing its myriad modernist treasures. We have usually started with a "theme" or focus - say, the work of Raphael Soriano, the late houses of Richard Neutra, the "suburbs" of Pasadena, or Modernism in Long Beach - but we have never resisted detours and deviations, which have sometimes become the best discoveries of all. When all four members cannot get away, the touring has continued with three or sometimes two. On all of these excursions, we have schmoozed incessantly on the pros and cons of modern architecture and design, particularly in Southern California. This has included the early regional legacies of Irving Gill, Charles and Henry Greene, and Frank Lloyd Wright, as well as the later work of the Case Study architects and the popular modernist variants from the twenties and thirties of the Art Deco and the Streamline Moderne. Yet any kind of "time/word count" of our various concentrations would probably reveal that the work we have most often visited, analyzed and discussed has been that of the two architects who still seem to us to be the central figures of Southern California modernism: Rudolph Schindler (1887-1953) and Richard Neutra (1892-1970).

Both men were born and educated in Vienna, counting as mentors, actual and spiritual, Otto Wagner and Adolf Loos. In the teens and early twenties, both found their way to Chicago and Wisconsin and to apprenticeships with Frank Lloyd Wright. Both came to Los Angeles in the 1920s, where Gill - reminding them of Loos - became an American father figure. Here, in 1921, Schindler built his own great double-house and, in 1925, rented one of its apartments to Neutra and his family, where they lived until 1930. In those same years, the two men shared a partnership in the Architecture Group for Industry and Commerce, parting acrimoniously after several joint projects, each to follow his own different trajectory.

Those similar beginnings and differing trajectories are stories told in great detail elsewhere. Since our Gang of Four early realized that complete consensus was impossible - and boring - we have enjoyed disagreeing on issues, large and small: the superiority, for example, of a certain figure's early architecture over his later designs, or vice versa; the successful, or disappointing, legacies of certain masters in the work of their disciples; or the links, and discrepancies, between various examples of exterior versus interior design. Yet we have also found much upon which to agree: [1] The importance of Southern California as one of the twentieth century's most significant places in the development of modern design. [2] The belief that Modernism was not *one* thing, but many things, which included a rich variety of non-mimetic expressions from the Rationalism of Neutra, Gill, and the Case Study architects to the Expressionism of Schindler, Lautner, and the senior and junior Wrights. [3] A conviction that the *differing* achievements of Schindler and Neutra are still under-appreciated keystones in modernism's global history. [4] The certainty that while individuals may reasonably prefer one of those architects over the other, there is now no need to have to choose *between* them since their individual achievements must not now seem to be in conflict - as they and their disciples sometimes were in life. This is because a healthy "both/and" approach has replaced the dated "either/or" conflict when one was expected - as a card-carrying "Schindler-ite" or "Neutra-ite" - to choose categorically between them. [5] Whatever "rank" or place one might give to Schindler's great architecture in the pantheon of modernism, there is virtually no challenge to the contention that his *furniture* holds a place at the very top of twentieth century design. It is that conviction that has rationalized this catalogue and exhibition.

Building on the important 1996 exhibition and catalogue, *THE FURNITURE OF R.M. SCHINDLER*, curated and edited by Marla Berns for the University Art Museum, U.C. Santa Barbara, the quantitatively small but qualitatively large presentation of Schindler's furniture for the Gingold collection - not a part of the Santa Barbara exhibition - is now before us as another confirmation of Schindler's unique genius.

right **House for Herman Sachs**
1926 -1940 Silver Lake

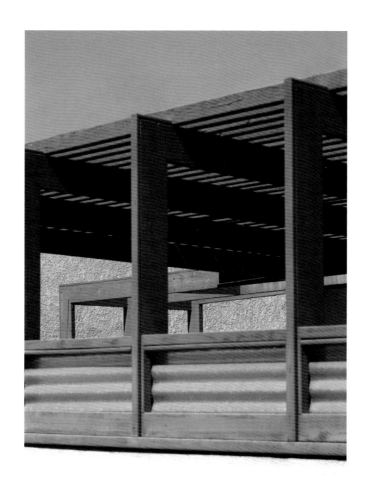

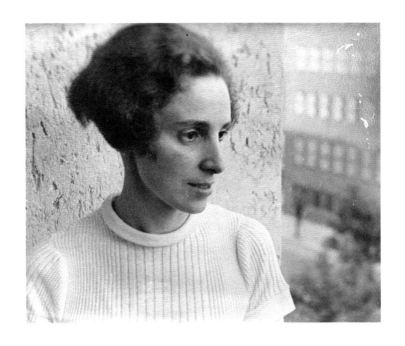

Basia Gingold
c. 1935

Basia Gingold, 1903 – 2006

Gerard O'Brien

Basia Gingold was born in Warsaw, into a German Jewish family. While still a young girl the family moved back to Berlin. Basia made her career choice in childhood. Hidden under a table, secluded from her six siblings, she would open dolls to study their insides. Though never encouraged by her parents to become a doctor, she managed to assert her will and this early challenge built toughness in her character. Her cousin Eva describes Basia as: "not overtly affectionate... she was so helpful, sometimes too direct, to the various members of the family in many situations." Her profound intellectual curiosity, not just in medicine, but also in art, music and literature, kept her socially active. Always ahead of her time, she was diet conscious - avoiding fats, and ingesting one buffered aspirin daily for decades. Achieving success as a medical student, she quickly became a leader amongst her peers. But the political climate in Germany in the early 1930's was not favorable for a pioneering, independent, Jewish career woman. Basia came to Los Angeles by way of France in 1935, having fled Berlin soon after the burning of the Reichstag in 1933. Always outspoken, Basia had dared to suggest that rather than the communists, the fires had been started by the Nazis "just as Nero had burned Rome." This comment was enough to send the Brown Shirts to her home. Upon their arrival and their inability to find her, they suggested to her family that it would be best if she not be found there anymore. Arriving in Los Angeles with no more than a grand piano, Basia began what would become a family trademark - reaching out to help relatives. In 1937, her thirteen-year-old cousin Eva came to live with Basia for two years, in order to escape the tumultuous times in Berlin. Eva loves to recount the story of being met by Basia in New York, traveling together to Detroit where she purchased a new car, and driving the car on to Los Angeles. "Imagine the force of a woman that would undertake such an endeavor in these times and for me, this young girl of 13, it was quite the adventure." After having to re-complete studies in America to pass the boards, Basia established an internal medicine practice in Los Angeles in the late 1930's. Not surprisingly, her intellectual interests led her to join the thriving community of expatriot Austro-Germanic intelligentsia in Los Angeles. She counted among her friends Robert Oppenheimer, Alma Mahler, and Lion and Marta Feuchtwanger, who were frequent guests at her formal European lunches. As Eva recounted, "Rudy was often there." It is at this point that we wish we could tell more about the Gingold/Schindler relationship from the point of view of either

entrance to Manola Court apartment
photo: Los Angeles, 2006

of the principals, but sadly they are both gone. What we do know is that Basia enjoyed a 15 year collaboration with Schindler. She remained an important client for a decade encompassing three separate commissions. By the time Eva joined Basia in 1937, she was in residence at the Herman Sachs Manola Court Apartments on Lucile Avenue in Silver Lake. It was here she was introduced to Schindler's space architecture. His philosophical approach revolved around a clearly defined use of materials and space intended to encourage a more humane living environment. Schindler's philosophy was clearly aligned with her own. Basia was reputed to enter someone's home and immediately recommend a better flow and layout of its furnishings. She sometimes took it upon herself to shift sofas from one end of a room to the other while a host was in the kitchen. She felt so strongly about her surroundings that she took the Sachs furniture with her when she moved to Beverly Hills. In 1940, when more family members fled persecution in Europe, Basia purchased a home in Beverly Hills, at 514 N. Alta Dr. with her sister Lolli and brother-in-law Roberto Sloan. Although it was a Spanish-style house, Schindler was comissioned to design the interior. This type of commission comprised the bulk of Schindler's wartime designs, as it was prohibited to build new homes with the war effort in full stride. Basia's next commission was her office in the Wilshire medical office building at 8352 Wilshire Blvd. In his notes on the inventory sheet for Basia's office, Schindler made a reference to "old chairs" which Basia had incorporated into the space along with new pieces. The façade was also addressed. By 1946 Basia had plans to expand her operations and retained Schindler to build a large, new medical office building on San Vicente. It ran the entire block from San Vicente Boulevard to Gale Street and included other doctor tenants as well as an on site pharmacy. What exactly went wrong between Schindler and Gingold is not clear, but a bitter dispute culminated with a lawsuit. Consequently, the building is not recognized by the Schindler archive as his building. However, many drawings for the building are included in the Schindler archive as an "unidentified medical building". The name "Gingold" clearly appears in script on the margins of a rough overhead floor plan, with budget notes as well as income projections. To the Gingold heirs it was always considered as having been built by "Rudy," despite the unfortunate lawsuit. The final transaction between Rudy and Basia was a payment for $1,000 made in 1951, perhaps part whatever settlement was reached. By 1953 Schindler was dead.

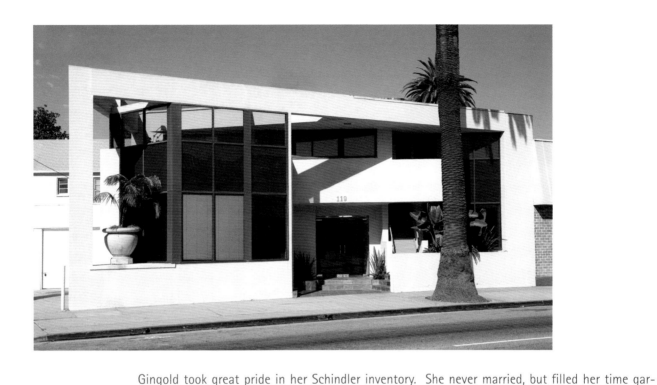

San Vicente medical office building
photo: Los Angeles, 2006

Gingold took great pride in her Schindler inventory. She never married, but filled her time gardening and participating in professional and Jewish organizations. She was an early supporter of Friends of the Schindler House, which was started in 1977 to preserve the decaying Kings Road residence. When she sold the San Vicente office building, she donated several chairs and a drawing of the façade of the San Vicente building to the Friends. Beyond this gesture, none of her pieces were lent for exhibitions, and the Gingold name is no more than a small footnote in the Schindler archive. Gingold remained at the Alta residence until 1981, when she sold the house and moved to La Jolla, taking along with her the complete Schindler collection. During her years in La Jolla, she traveled frequently to Israel and South America. In 1984, on a trip to Mexico, she struck up a new patronage with the expatriot German sculptor Mathias Goeritz. Basia died on February 14, 2006 at the age of 103. The family eulogy of this distinguished centenarian noted, "Her spirit will live on through us, her nieces and nephews, her tastefully aquired belongings, and it will soar like the gigantic, abstract, yellow bird sculpture by M. Goeritz which graced the view in her carefully tended garden."

13

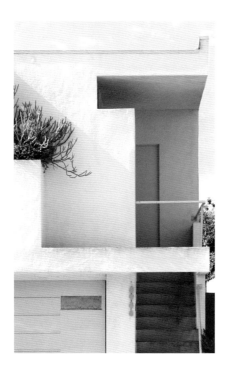

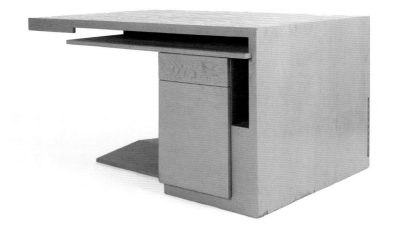

left **Schindler Buck house** (detail)
1934 Los Angeles, CA
photos 2006
above **partners desk**
c. 1943 Gingold residence

Furniture As Micro Architecture:
R.M. Schindler's Gingold Commissions

Michael Boyd

When Schindler failed to receive architecture commissions, he gladly accepted contracts that called for the design and execution of furniture. One of the reasons for this, in addition to the obvious necessity to keep working and earning, was the fact that, although the scale was smaller, he was still creating architecture. Ratios and pitches, systems, and sense of space—all were brought forward from Schindler's vocabulary in buildings into the scaled down world of furniture making. The French consider the two to be closely related—the French word for building is *immeuble*, literally translated as "unmovable," and the word for furniture is *meuble,* meaning "movable". The 1940-1950 Gingold commissions and the 1934-38 Shep commission, two of the larger projects of this kind, called for as much as twenty new pieces of furniture for existing spaces or retrofitted interiors.

In the office of Frank Lloyd Wright, Schindler had been responsible for projects of this scope: the designs for furniture and appointments at the (1923) Freeman house in Los Angeles, which involved articulating the spaces that Wright had conceived. The freestanding furniture was architecture in its own right— a kind of micro-architecture. But part of the idea was to extend the language of forms at play in the building and interior. Cantilevered overhangs, banding details, an emphasis on horizontality--all reflected and reinforced the built surroundings. So if the big budget or house project was not available to Schindler, he would go about his designs for the furniture commissions with the same delicacy and determination, proliferating a planar universe all over Southern California.

Like his friend and colleague Richard Neutra, Schindler emigrated from Vienna, where the two were gifted students of Adolf Loos, to the United States, where, at different times, he and Neutra worked for Frank Lloyd Wright. Schindler was well versed in Loos' vision of strictness in form. Wright had been Schindler's idol when he was back in Vienna; Schindler greatly admired the images of Wright's strongly horizontal Japanesque structures in *Wendingen* and other progressive architecture publications. And ultimately Schindler became a masterful associate of Frank Lloyd Wright, although he soon outgrew the position. But whereas Loos believed that the use of ornament was a crime, Schindler went on to use the functionalist, stripped down simplicity, as a different kind of ornament. The poetics of the (1934) Buck House's cantilevered volumes have a geometrical rhythm that is very nearly decorative. Impressions in the concrete at the (1926-28) Sachs apartments appear both functionalist and decorative. The same sorts of rhythms can be seen in pieces of furniture from the Gingold commissions—not just the obvious cabinet/house comparison, but even in the doors and drawers of the interiors. The layered planes in just

a single cabinet door from the Sachs apartments recall artworks by the Russian Constructivist, El Lissitsky, or a sculpture by the Belgian avant-garde artist George Vantongerloo. The stepped composition of the sideboard and rolling sofa from the same commission-- each cubist volume overtaking the one underneath--is sympathetic to the architectonic models of Kazimir Malevich. The Sachs sculpture plinth projects like a sky scraping tower--designed a full five years before William Lescaze and George Howe created the PSFS in Philapdelphia (1931). Scalloped layers, cubes, and other themes that appear in machine age aesthetics, all are implemented in the Sachs and Gingold designs, but with strong emphasis on horizontality. Schindler's universe was undeniably constructivist, forward thinking, and free. For the inhabitants of his buildings as well as the owners of his furniture, Schindler was adamant about a meaningful quality of life. Concerns about health and hygiene and clean open space took precedence over any dogmatism he may have picked up from Loos or Wright. Perhaps not as fixated on permanence and ego as the two masters, Schindler chose to concentrate on the conceptual or aesthetic aspects and made allowances (but not concessions) only at the manufacturing level. Doors from other cabinets could be used as scrap materials for somewhat primitive extensions on new work. Finish level was not the main priority; execution could appear rustic and home made. Schindler's implied social program won out over objective concerns. Like the futuristic film sets of Robert Mallet-Stevens, the similarly inclined French modernist architect, Schindler's vocabulary, over and over, is planar. There is no room in this ideology for Aalto or Breuer-like biomorphism. Curves appear only in the form of the pure circle or half circle. The most unfussy route to functional and beautiful design for Schindler lay with the rectangle and square. Where planes intersect certainly can involve intricate layering, but overall, it is the simple and pure, wide, low, world Schindler wants us to inhabit. Humility, simplicity-- "plainness," as he called it, was difficult to achieve, but a worthy pursuit.

The notion that furniture is viewed as micro architecture surely did not originate or end with Schindler. Mackintosh and Rietveld before him, and Eames and Perriand after him, among others, all created pieces of furniture that literally had the appearance of small buildings. Many of these designers have written or said that there is essentially no difference between building a building and building a chair—they are on a continuum. Yet Schindler was a singularly gifted practitioner of furniture design. Although Neutra, who sometimes had a way of overshadowing Schindler, is inarguably a master of modern architecture, his furniture designs are unspectacular. Schindler truly had a vision for furniture design, maybe only

partly because of his greater participation in its practice than his rival. Unlike Neutra, who wanted to reduce every element to the most minimal to arrive at a final design, Schindler instead was comfortable inventing and exploring the language of constructivism in series and variations (like Bach organ fugues). Utility and replicability were foremost on Neutra's mind. Utopia was foremost on Schindler's. I will never forget the first time I visited Schindler's Buck house of 1934; I was struck by how enormous the implications and suggestions were—although the house itself was small (even tight because of the low ceilings). But the layout of the grid and its interlocking planes, opening to the outside in all directions, created a magical and open environment. And the compression/release is also seen at the Kings Road Schindler house of 1921-22; narrow quarters yield to outdoor sleeping decks under towering bamboo. Again, the entire building feels like scaled up cabinetry. The Schindler house and the Buck house, like Rietveld's Schroeder house (1924) in Utrecht, and Eames' own house in the Pacific Palisades (1950), gives the impression that it is a large piece of furniture. So why shouldn't it work the other way? If the diminutive houses can appear to resonate like gigantic case goods or furniture, can't the furniture feel like miniaturized buildings? J.M. Richards, the architecture critic, has connected the sublime furniture designs of Charles Rennie Mackintosh to his architecture and buildings: "The furniture has the elegance and wit for which his architecture was already remarkable." It's more than just personality coming through, or a manifesto taking hold. For Schindler the pitch perfect proportions, present in his utopian buildings, resurface in the bold and progressive furniture. Design and engineering, form giving and future vision--project big or small—ideas for objects can have equal impact despite the object's actual size.

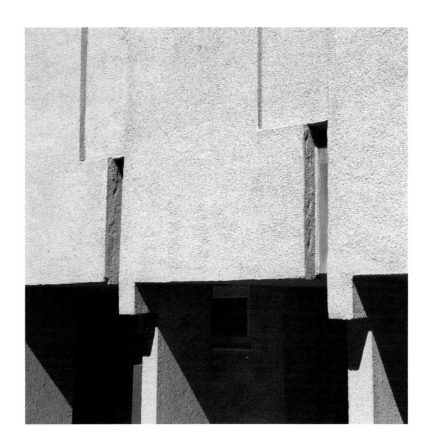

Manola Court apartments (detail)

R.M. Schindler:
Pioneer Without Fears

Mark Lee

Recantations are rare occurrences in architectural history. In most cases, oversights or premature denouncements are mitigated in the form of subtle reappraisals or retroactive inclusions, as in the case of Aalto's increasing coverage in revised editions of Sigfried Giedion's *Space, Time, and Architecture*. Contrite refutations of one's earlier convictions, however, are rare. In recent history, one recalls some memorable retractions from Robert Venturi, who rescinded his criticisms of Michelucci's church for the Autostrada in his second edition of *Complexity and Contradiction in Architecture*, admitting he had not seen the church when he wrote the first edition; or later renouncing his condemnation of the importance of Mies van der Rohe ('Of all the things I have said.....the only thing I would take back is "Less is a bore"'). Since revisionist positions are scarce occurrences, they are worthy of one's attention.

Besides charting a critic's changing disposition or signifying larger paradigmatic shifts within the critical establishment, recantations reflect the subject's inscrutable complexity which solicits misjudgments in the first place. In modernist history, the work of R. M. Schindler is the subject of more than one such reappraisal. Having excluded Schindler from the International Style exhibition of 1932 at the Museum of Modern Art, both Henry Russell Hitchcock and Philip Johnson expressed regret for underestimating the importance of Schindler's output. In his preface to David Gebhard's book, Hitchcock reassessed Schindler's contribution to the modern movement by quoting his own earlier incomprehension of the work. Johnson, when asked about his dismissal of Schindler in the exhibition, frankly referred to the omission as a mistake. Even Gebhard, the author of the first comprehensive book on Schindler and an early champion of the work, rescinded his earlier criticisms on Schindler's later projects.

Certainly, much has been written since then to redeem the prominence of Schindler as an architect ahead of his time with invigorated interest in his precociously modern project. The architects Hans Hollein, Herman Hertzberger, Jacob Bakema, and the critics Bruno Zevi and Reyner Banham, were the first in the sixties to 'rediscover' Schindler by introducing his work to a European audience at a moment when the orthodoxy of high modernist tenets was challenged. American architects and scholars, viewing Schindler with the critical distance of time, took renewed interest in the work of this then problematic figure. And while little need be added today to reaffirm the significance of Schindler's career, the gradual acceptance of his work has propagated a body of discursive material along the way which requires deeper scrutiny. Contemporary criticism that examines Schindler within the context of the modern movement highlights his political dispositions or compares his career with that of Richard

Neutra, merits refinement. On one hand, Schindler never unilaterally embraced the Modernist idiom. Only occasionally did he utilize the light-colored wall, the strip window, or industrial materials in his work. On the other hand, Schindler adopted a nebulous and less graspable ideology than the ones forwarded by members of the critical establishment, which he articulated early on in his 1913 manifesto declaring space, instead of form and matter as the architectural material of the new age. Rejecting the polemical mantra of modern architecture as a "machine for living," Schindler instead put forward a humanist argument that aspects of modernity be developed in relation to natural evolution rather than mechanical repetition. As institutional patronage towards modern architecture in America congealed at the International Style exhibition, the projects selected by Hitchcock and Johnson became the culturally accredited instrumentalities of modern architecture. Schindler's individualism and idiosyncrasies were the very qualities denounced by critics preoccupied with a belief in the objectification of the architect's individual consciousness into a larger movement. Schindler's leftist politics and bohemian lifestyle further mystified the cult of his personality. His interest in progressive social and political causes is manifested in the soirees at his Kings Road House. And in many ways, the double house is synergetic with the cooperative ownership and egalitarian communal living it embodied. But one could not help but wonder if the slippage between form and ideology, or in Colin Rowe's terminology - between the physique and the morale in architecture, has diluted the comprehension of the work itself. In the same way Kenneth Frampton has observed that Frank Lloyd Wright's Broadacre City corresponded more closely than any other form of radical urbanism to the central precepts of the Communist Manifesto of 1848, Schindler's architectural agenda is intrinsically detached from his social-political agenda.

And it would have been more projective to understand Schindler's work by tracing the lineage of spatial strategies from Otto Wagner to Adolf Loos to Frank Lloyd Wright (i.e. adopting Wright's plans into sectional strategies for difficult hillsides), than to confound it with biographical aspects which, more than often, digressed from the architecture. When Schindler died of cancer in 1953, his position in the modernist project had largely been marginalized. When compared to his fellow Viennese émigré and former collaborator Richard Neutra, Schindler was often cast as the misunderstood iconoclast who was unable to attract larger commissions. Neutra, who was included in Hitchcock and Johnson's exhibition, went on to become a critically acclaimed and prolific practitioner. But while Schindler's career was eclipsed during his lifetime by Neutra, his lack of large commissions had prompted a degree of experi-

mentation and speculation on an intimate scale that in time gained its own cult following. Being limited by modest budgets, Schindler often acted as both architect and general contractor and became a pioneer in early uses of economical materials and construction methodologies: (e.g. the Slab/Post Concrete Construction System of 1923 and the Panel/Post construction system of 1943). He distilled the essence of his 'Space Architecture' to a scale of small commissions – from houses to renovations to furniture design. And while Schindler's buildings are often fragile; his furniture is well constructed and belongs to a scale he was able to master. Adapting Adolf Loos' distinction between built-in vs. free floating furniture, Schindler's furniture pieces are both integrated and part of the architecture, and architectural elements in their own right.

In hindsight, not only was Schindler's career a forerunner of a new plasticity, it played an important role in resuscitating interest towards projects that were once deemed to perpetuate a personal, expressionistic intent that undermined the rigor of mainstream modernism. And as more projects such as the Gingold Commissions begin to resurface, one can not help but think that the unfolding of Schindler's importance has yet to see its final chapter.

catalogue

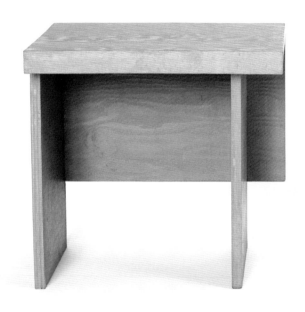

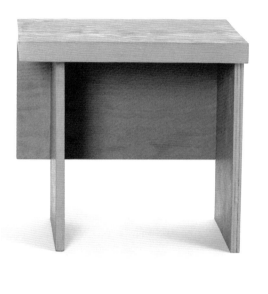

pair of cantilevered side tables
Wilshire medical office, c. 1945
17"h x 18" x 15"

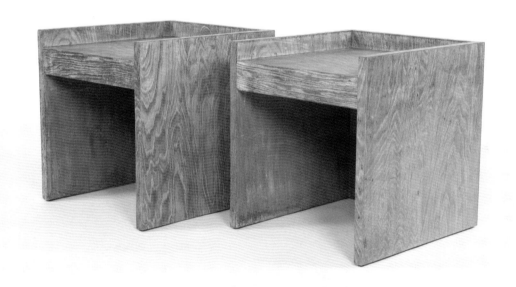

pair of convertible table/chairs
Wilshire medical office, c. 1945
17"h x 20" x 15"

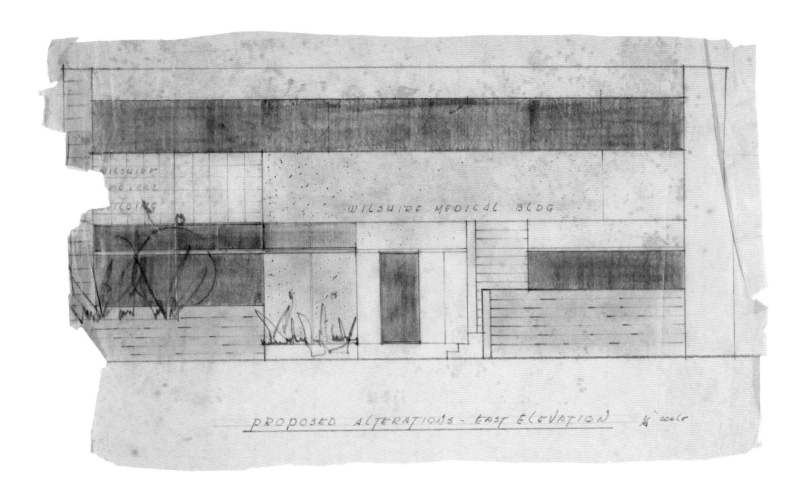

WILSHIRE MEDICAL BLDG

PROPOSED ALTERATIONS - EAST ELEVATION ¼″ scale

architectural drawing
medical office for Dr. Basia Gingold
8"h x 13"

26

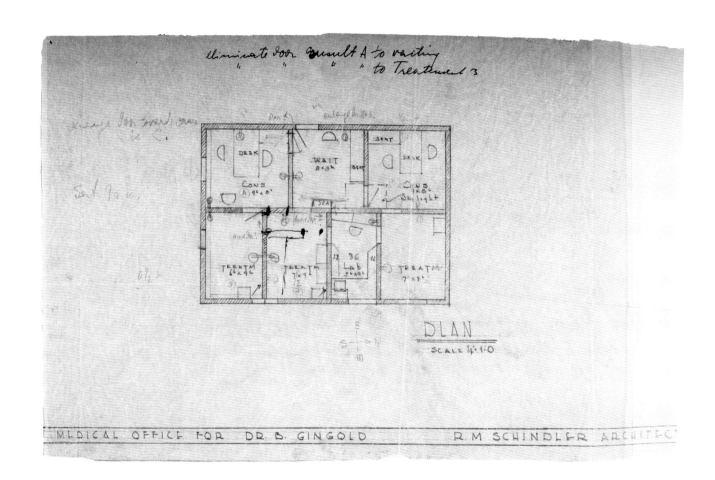

architectural drawing
medical office for Dr. Basia Gingold
11.75"h x 21"

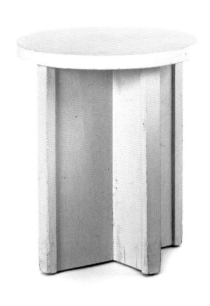
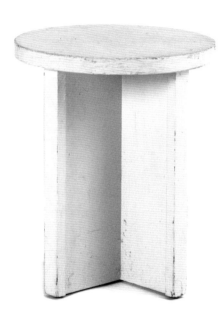

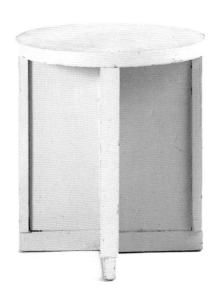

left pair of circular tables
Wilshire medical office, c. 1945
16.75"h x 14.25"diameter and 16.75"h x 14"diameter
above circular stool
Wilshire medical office, c. 1945
14.25"diameter x 15.75"h x 14"d

29

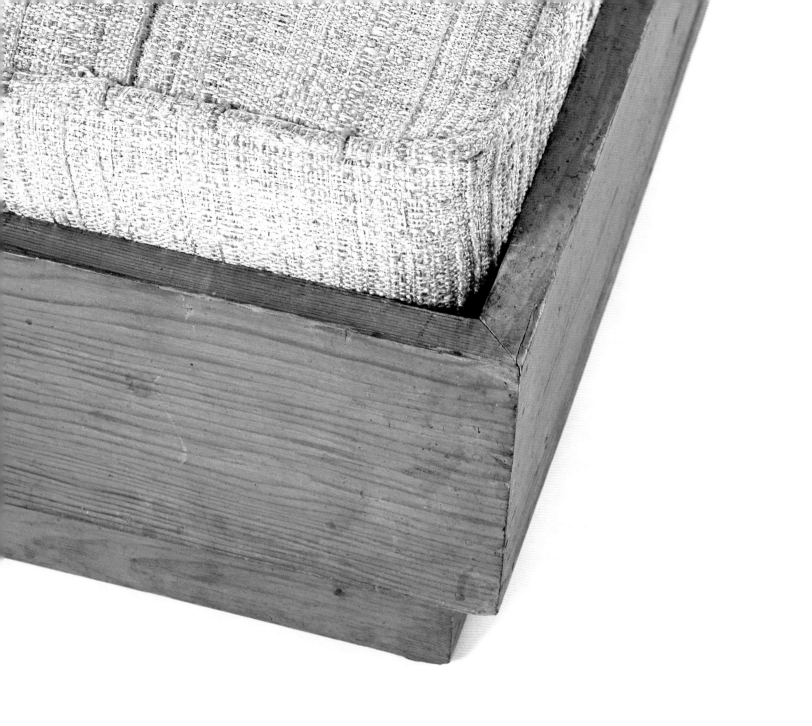

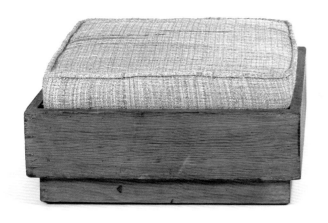
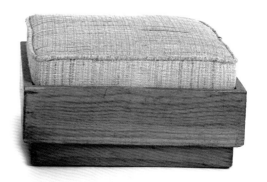

pair of hassocks
Gingold residence, c. 1943
9.5"h (to top of cushion) x 19" x 19"

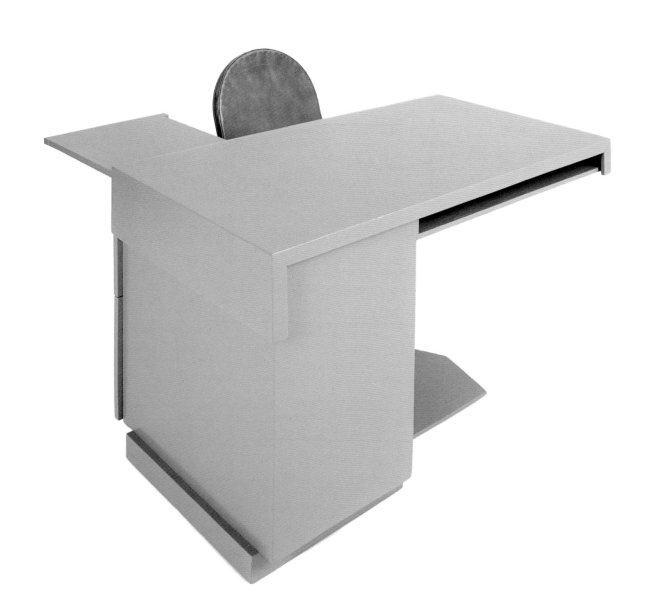

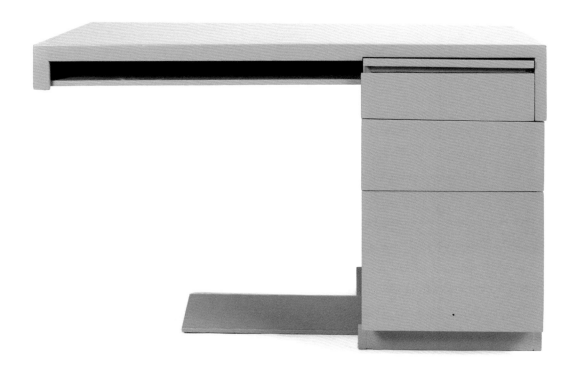

cantilevered desk
Wilshire medical office, c. 1945
28.5"h x 25"d x 48"l

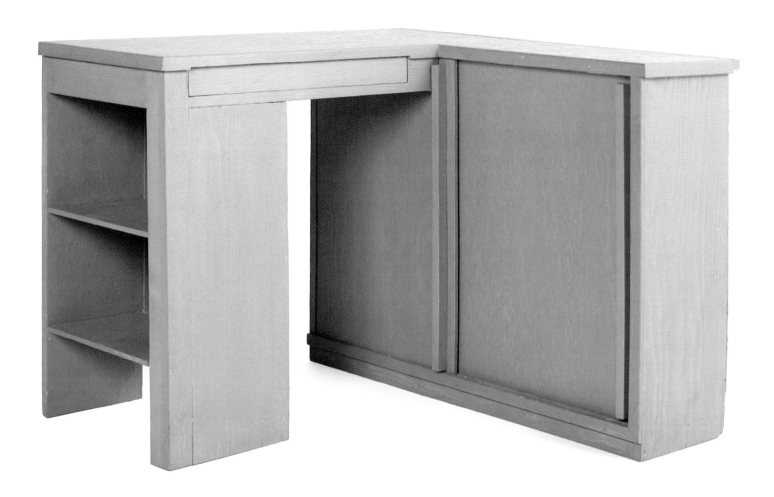

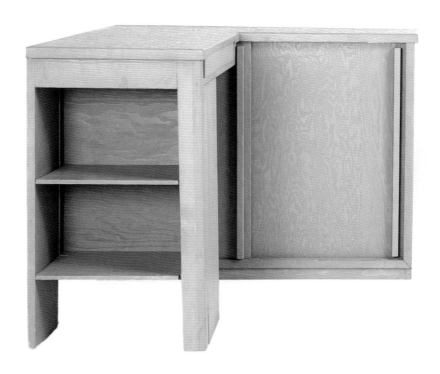

corner built-in unit
Gingold residence, c. 1943
28.5"h x 38.5"max width x 37.25" max depth

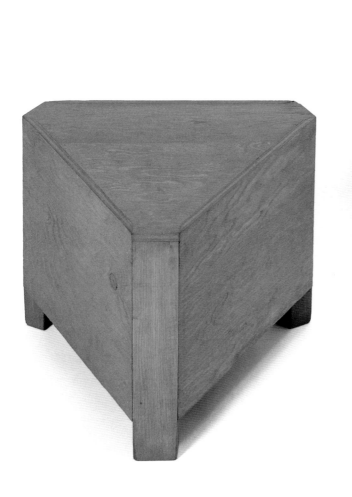
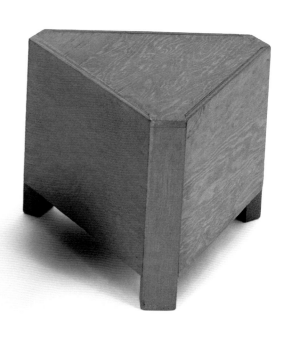

left pair of tables
Wilshire medical office, c. 1945
14"h x 15.25" x 17.5"
above stool
Wilshire medical office, c. 1945
15.5" x 15.25" x 17.5"

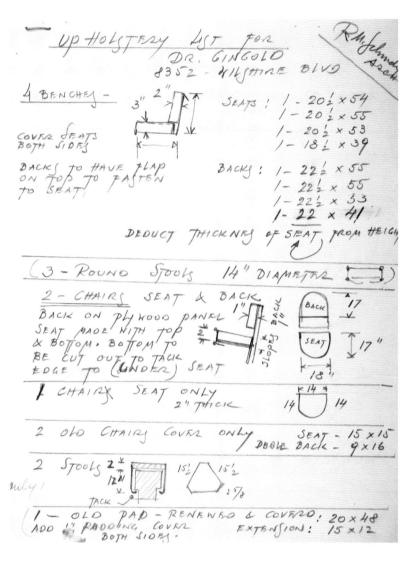

UPHOLSTERY LIST FOR

DR. GINGOLD

8352 - WILSHIRE BLVD

R.M. Schindler Arch't

4 BENCHES -

3" 2"

COVER SEATS
BOTH SIDES

BACKS TO HAVE FLAP
ON TOP TO FASTEN
TO SEAT

SEATS : 1 - 20½ x 54
1 - 20½ x 55
1 - 20½ x 53
1 - 18½ x 39

BACKS : 1 - 22½ x 55
1 - 22½ x 55
1 - 22½ x 53
1 - 22 x 41

DEDUCT THICKNESS OF SEAT FROM HEIGH

(3 - ROUND STOOLS 14" DIAMETER)

2 - CHAIRS SEAT & BACK
BACK ON PLYWOOD PANEL
SEAT MADE WITH TOP
& BOTTOM. BOTTOM TO
BE CUT OUT TO TACK
EDGE TO (UNDER) SEAT

1"
2½"
SLOPES BACK 1"

BACK 17

SEAT 17"

18"

1 CHAIR SEAT ONLY
2" THICK

14
14 14

2 OLD CHAIRS COVER ONLY
SEAT - 15 x 15
DBBLE BACK - 9 x 16

2 STOOLS 2¼
12¼
only!
TACK

15½ 15½

2 5/8

1 - OLD PAD - RENEWED & COVERED: 20 x 48
ADD 1" PADDING COVER EXTENSION: 15 x 12
BOTH SIDES.

inventory list with drawing
Wilshire medical office, c. 1945
11"h x 8.5"

38

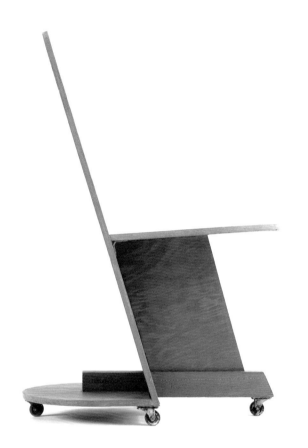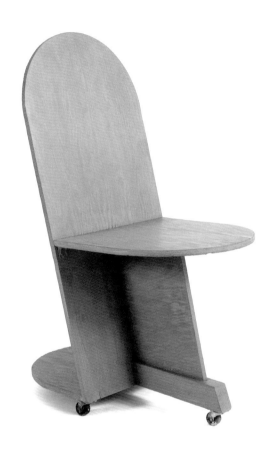

side chair
Wilshire medical office, c. 1943
31"h x 14"w x 22"d

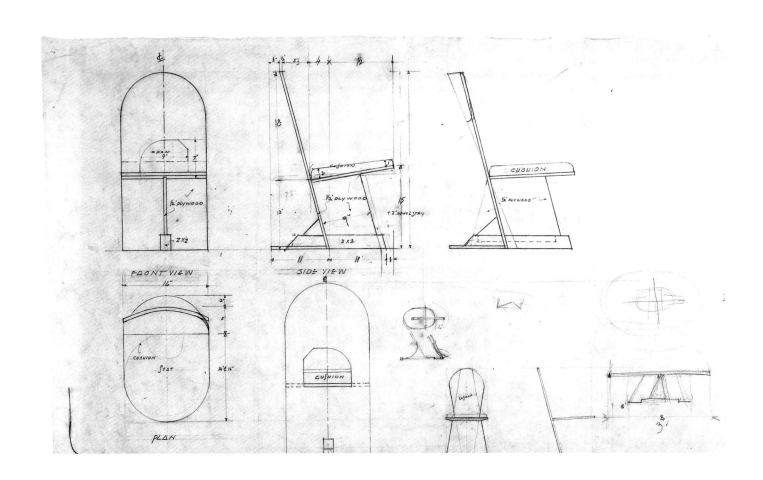

FRONT VIEW

SIDE VIEW

PLAN

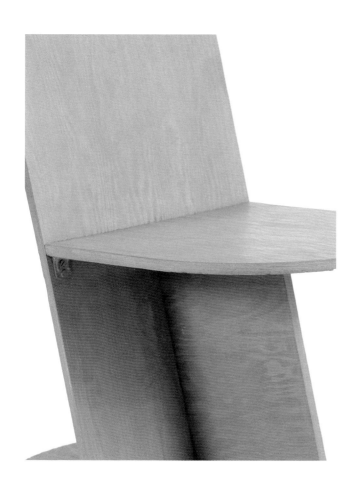

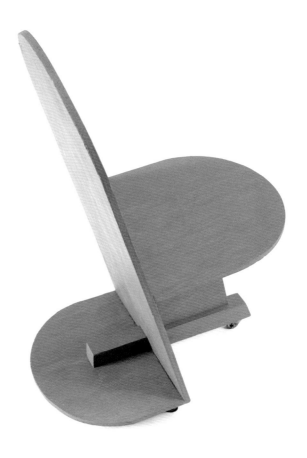

rolling chair
Wilshire medical office, c. 1943

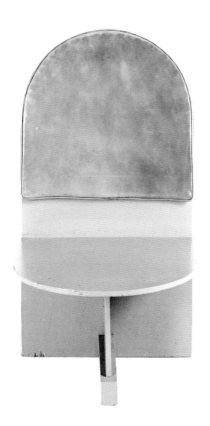

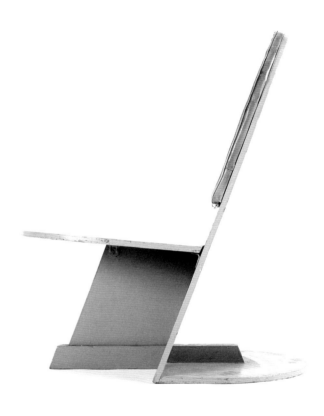

side chair with upholstered back rest
Wislhire medical office, c. 1945
31"h x 18"w x 27"d

42

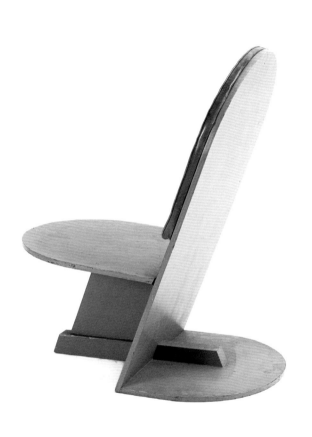
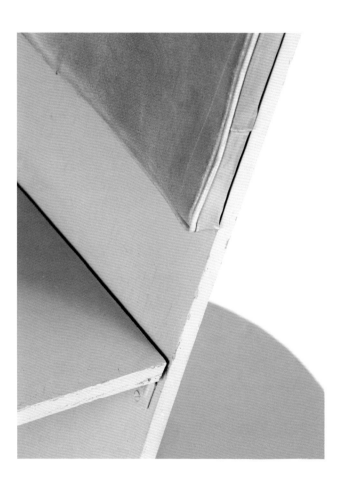

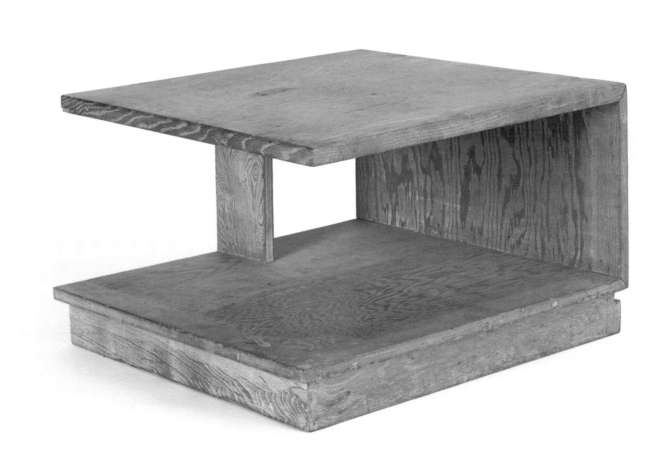

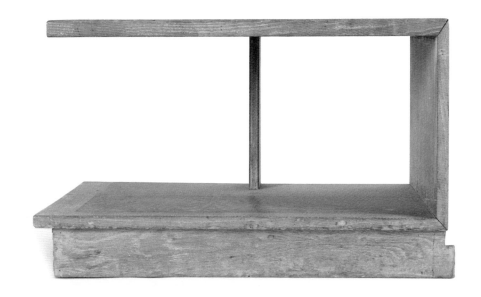

cantilevered end table
Wislhire medical office, c. 1945
14.5"h x 22.75"d x 24.75"l

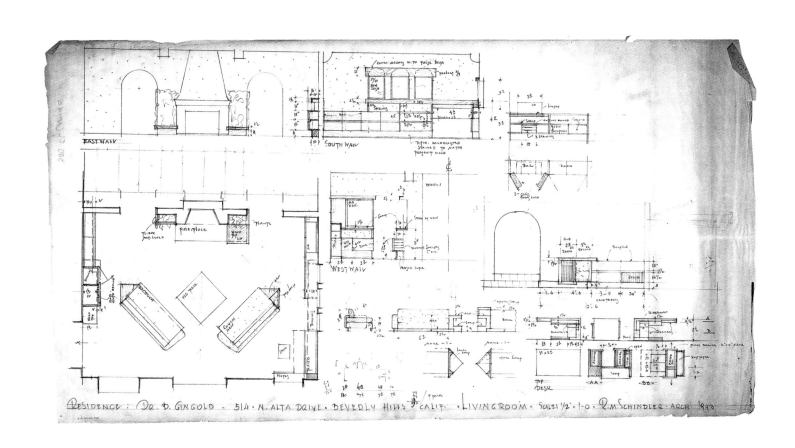

RESIDENCE : DR. D. GINGOLD · 514 · N. ALTA DRIVE · BEVERLY HILLS · CALIF · LIVINGROOM · SCALE 1/2"=1'-0 · R.M.SCHINDLER · ARCH · 1945

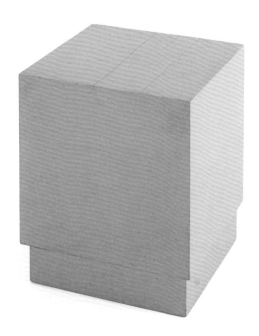

pedestal
Wilshire medical office, c. 1945
18.5"h x 15" x 15"

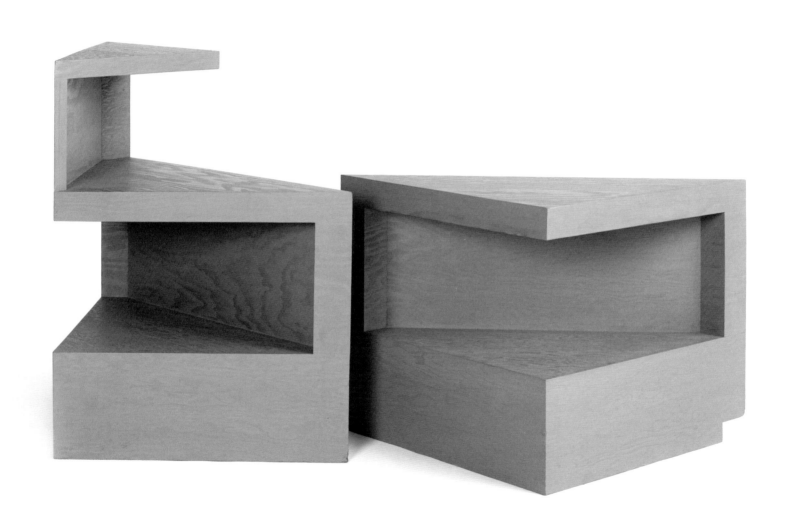

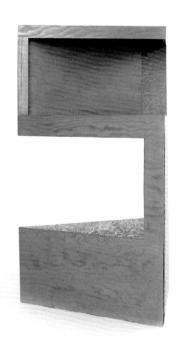
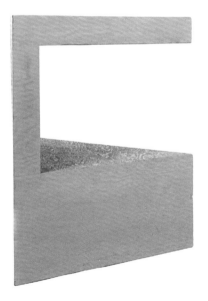

pair of end tables
Gingold living room, c. 1943
(end table left) 31.25"h x 17" x 34"
(end table right) 21"h x 17" x 34"

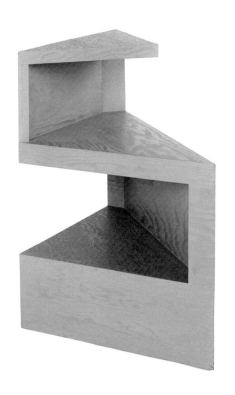

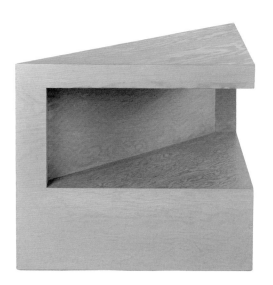

pair of end tables
Gingold living room, c. 1943

TWAIL

MUJIK cupe.

MAKE — 1 —

lower shelf

MAKE —

VERLY HILLS · CALIF. · LIVING R

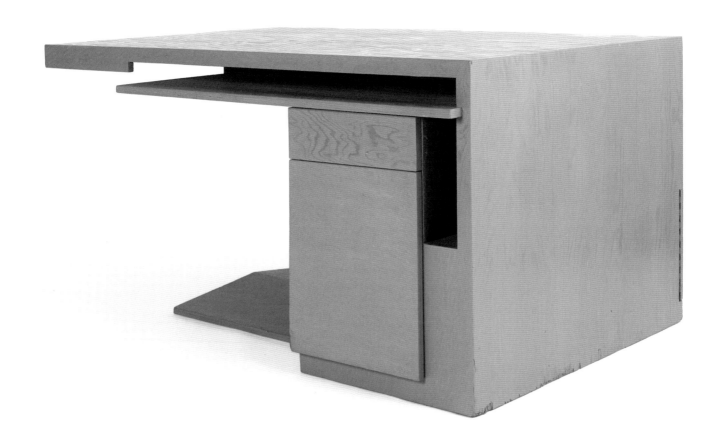

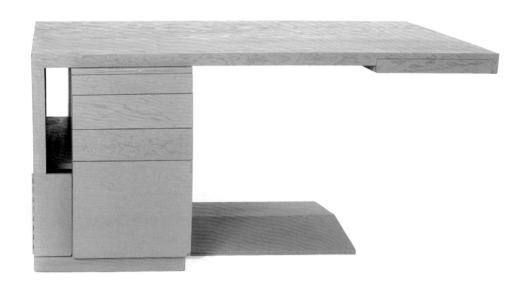

partners desk
Gingold residence, c. 1945
28"h x 38.5" x 59.5"l

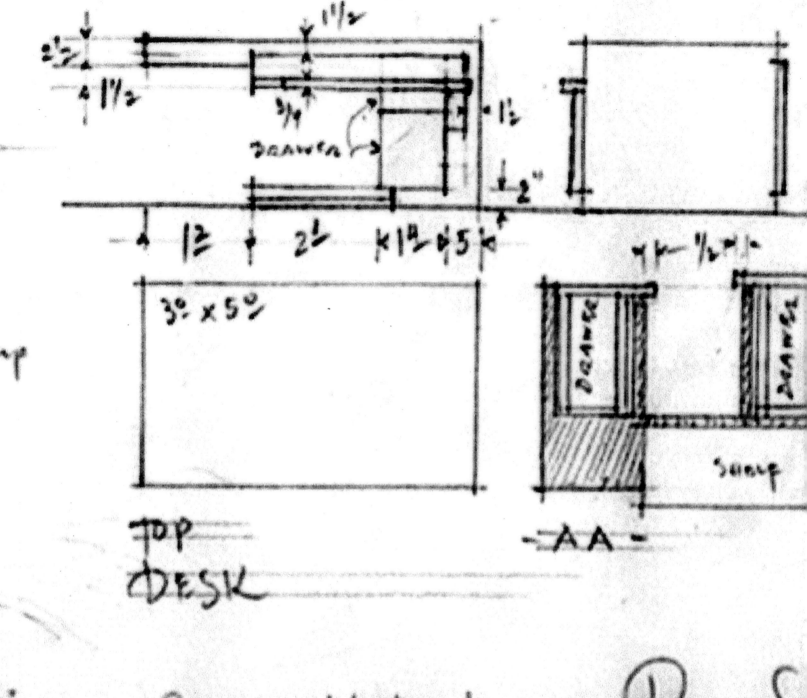

2½"

1½"

1½"

¾"

drawer

1½"

2"

12

2¼

1½ 5

3" × 5½

TOP
DESK

½"

drawer drawer

shelf

-AA-

M. SCALE 1½" = 1'-0". R.M.S

SLIDEBOARDS
1½

DRAWERS

A

2½

B

2½

open

½

FILING DRAWER 12"×12"

FILING DR.

WAST PAPER

LIN.
LIN.

1-2

-BO-

HINDLER · ARCH · 1943

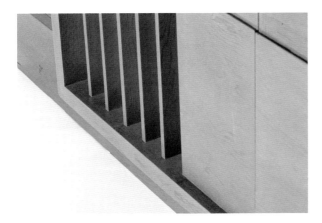

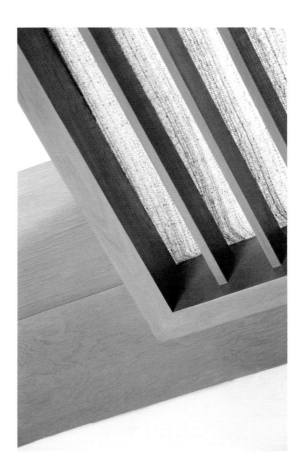

built-in radio cabinet
Gingold residence, c. 1945
40.5" x 150"l x 20"

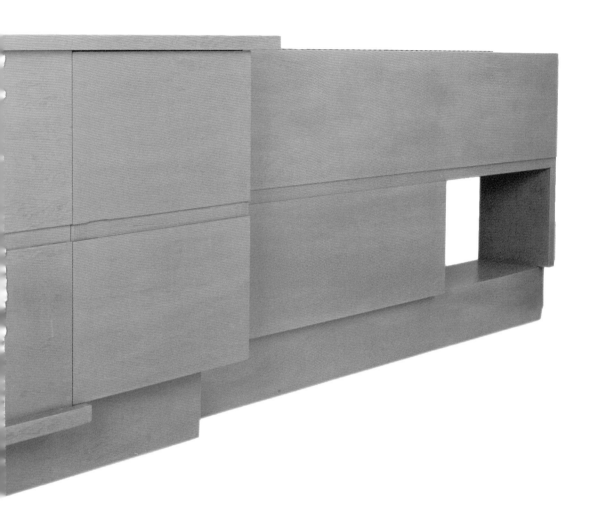

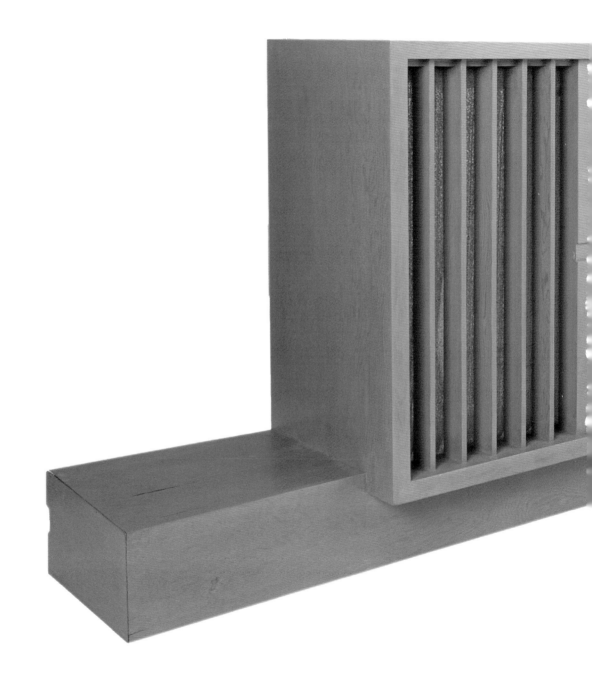

upper surface

1½

2½

1-6

1½

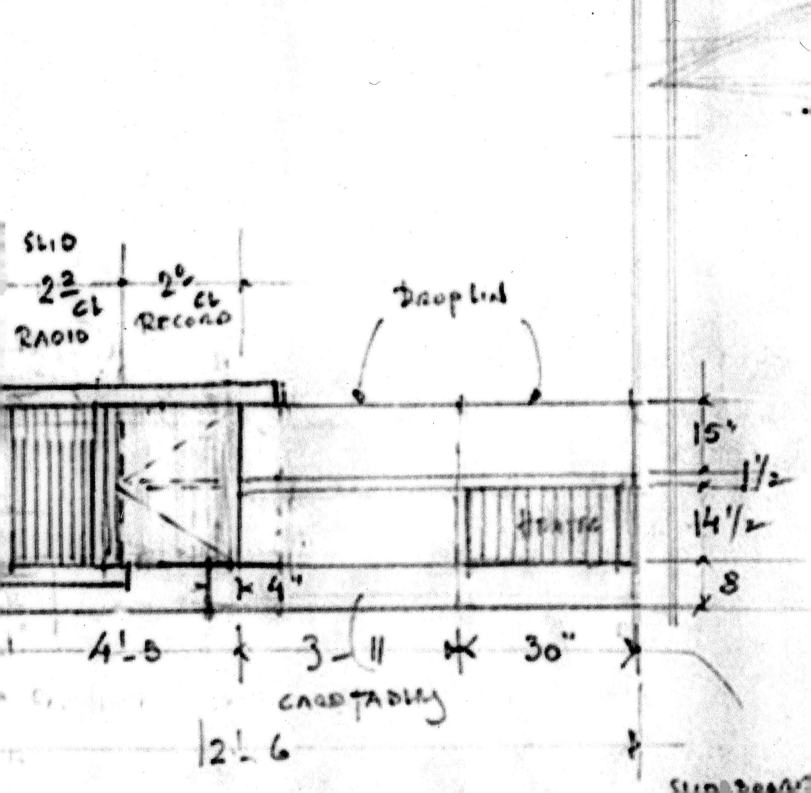

SLID

$2\frac{3}{4}$ CL
RADIO

$2\frac{0}{8}$ CL
RECORD

Dropleil

15"

1½

14½

8

4'-5

3 - 11

30"

12'- 6

CABT TADLEY

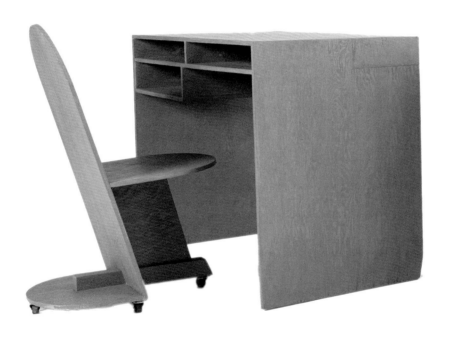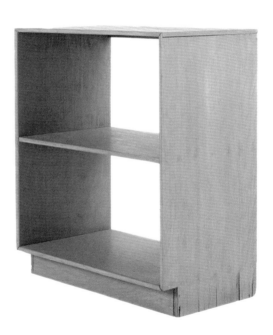

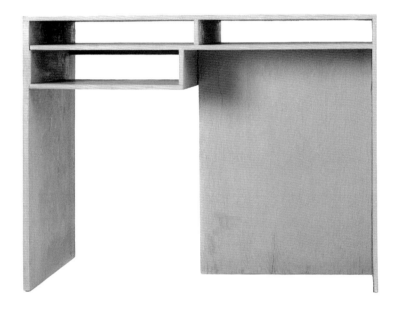

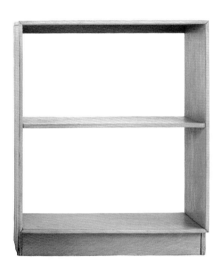

desk with freestanding shelf
Wilshire office, c. 1945
29"h x 38"l x 22"d

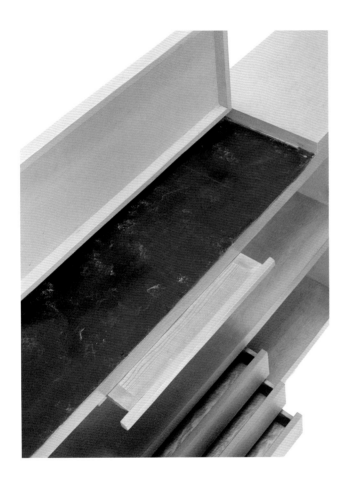

built-in radio/bar cabinet
Gingold residence, 1943-45
39.5"h x 15.5"w x 157"l

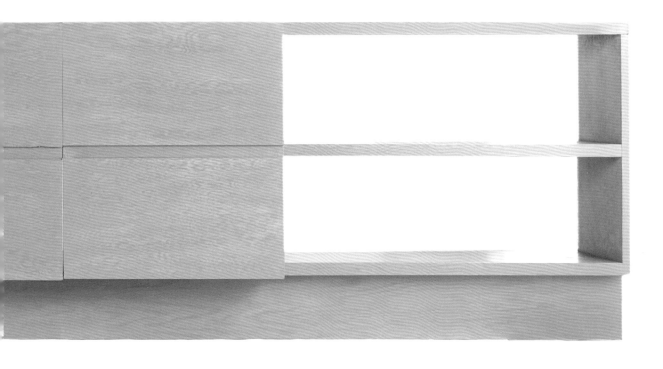

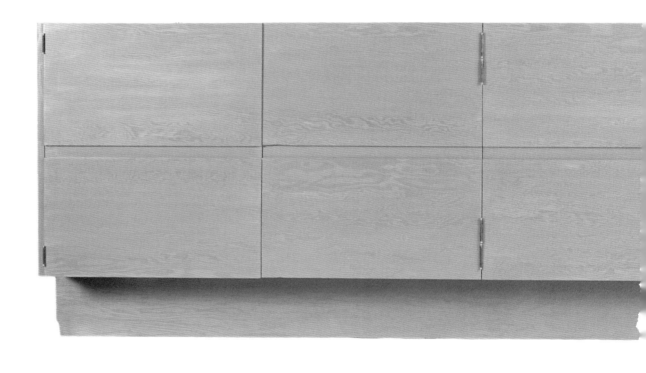

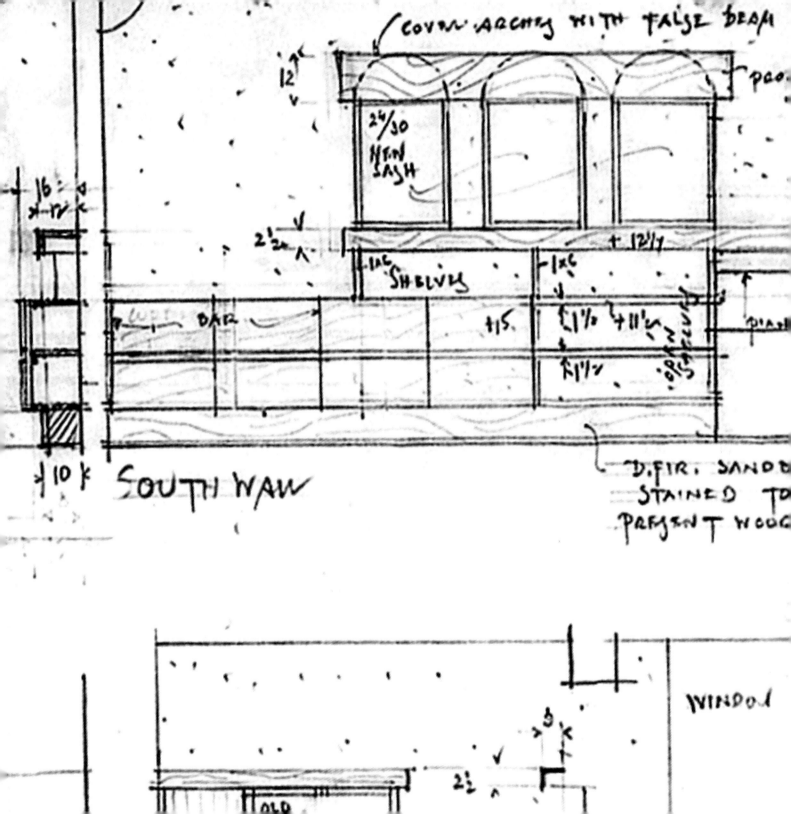

COVER ARCHES WITH FALSE BEAM

12"

24/30
MTN
SASH

2½"

1x6
SHELVES

1x6

BAR

+15.

{1½" +11½"

+1½"

+12½"

P.G.

PLAN

SOUTH WALL

+10

D. FIR. SANDE
STAINED TO
PREJENT WOOD

WINDOW

2½

OLD

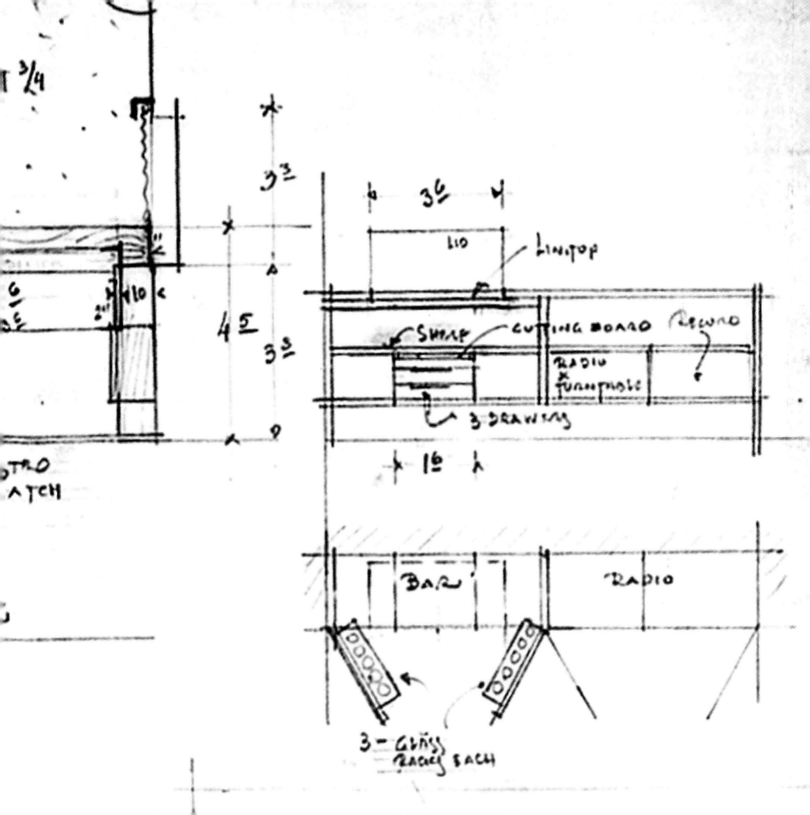

Schindler correspondence
dated November 1950, between Schindler and Basia Gingold
stationary 11"h x 8.5"w

ARCHITECT
R. M.
SCHINDLER
835
KINGSROAD
LOS
ANGELES
CAL'
TELEPHONE
NO.
MV 9011
DATE
nov. 2nd 1950
TO.
dr
BASIA
GINGOLD

BEVERLY HILLS.

DEAR DR. GINGOLD.

IN ACCORDANCE WITH YOUR REQUEST I
ENCLOSE THE NEW FORMS OF OUR ORIGINAL CONTRACT
COVERING MY SERVICES FOR THE PROPOSED MEDICAL
 BUILDING AT THE SAME CONDITIONS BUT CHANGING
THE OWNERSHIP.

PLEASE RETURN ONE SIGNED COPY.

SINCERELY

R.M.SCHINDLER

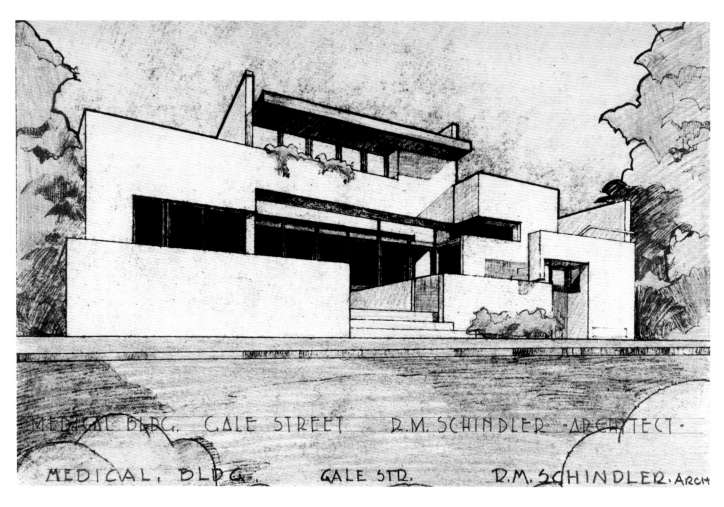

MEDICAL BLDG. GALE STREET R.M. SCHINDLER ·ARCHITECT·

MEDICAL. BLDG. GALE STR. R.M. SCHINDLER. ARCH

color rendering
Medical office building, Gale Street entrance.
8"h x 10.75"w

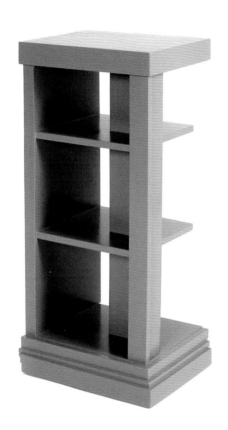

freestanding book case
Sachs apartment, 1926-40
38"h x 17" x 14"

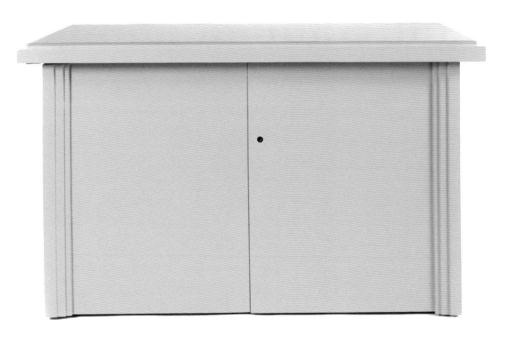

storage cabinet
Sachs apartment
1926-40
27.5"h x 27"d x 46.75"l

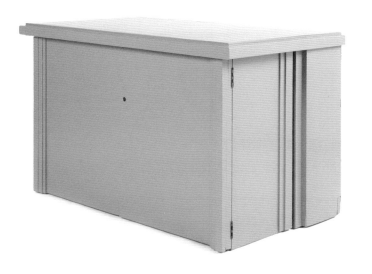

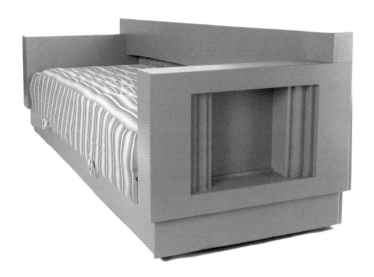

daybed
Sachs apartment
1926–40
31"h x 35.5"d x 101.5"l

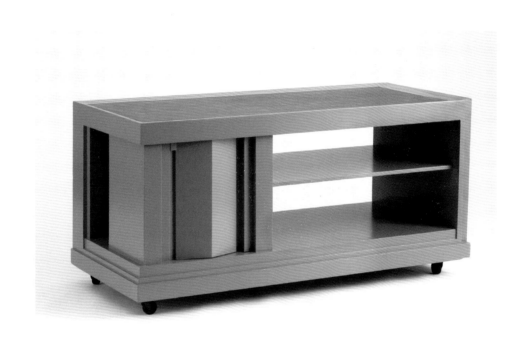

rolling storage cabinet
Sachs apartment
1926-40
22.25"h x 20"d x 46.25"l

74

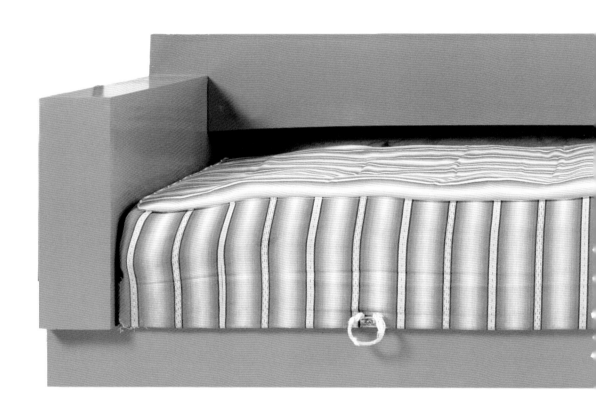

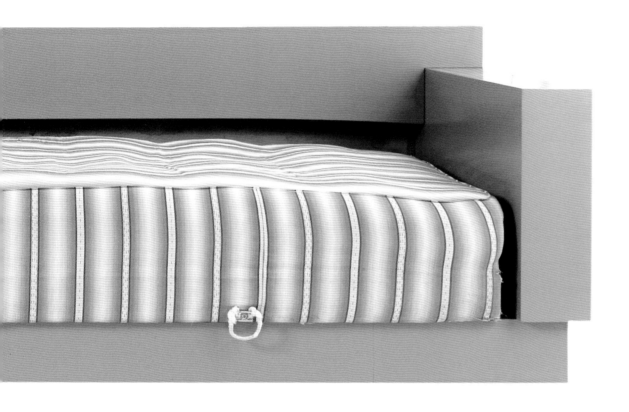

display cabinet
Sachs apartment
1926-40
28.25"h x 19"d x 38"l

76

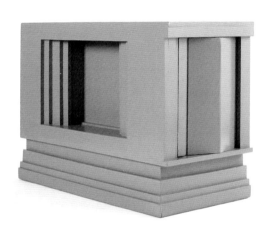

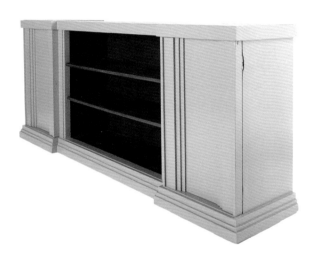

sideboard
Sachs apartment
1926-40
38.25"h x 20"d x 94.5"l

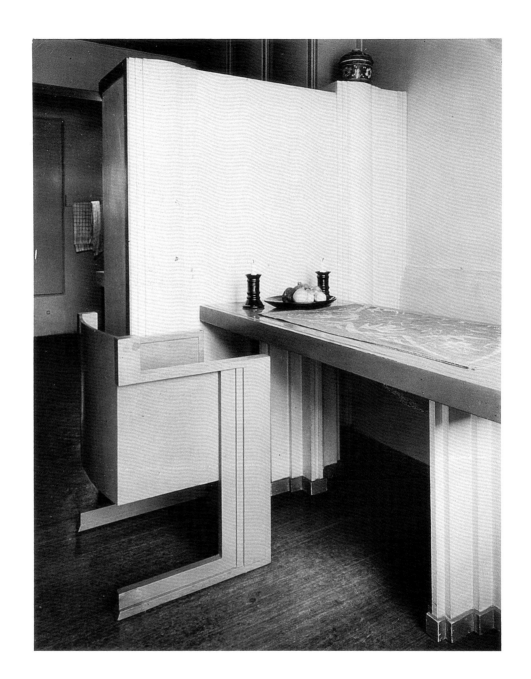

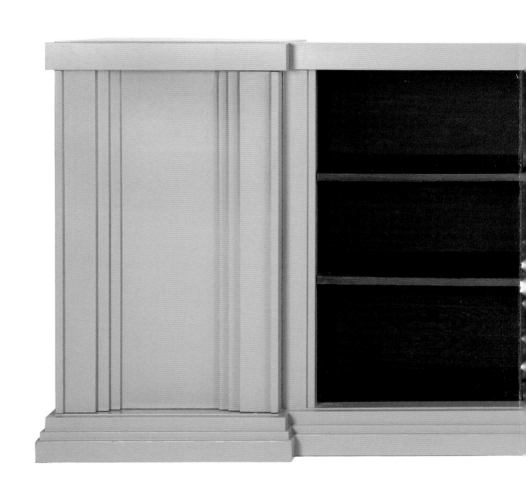

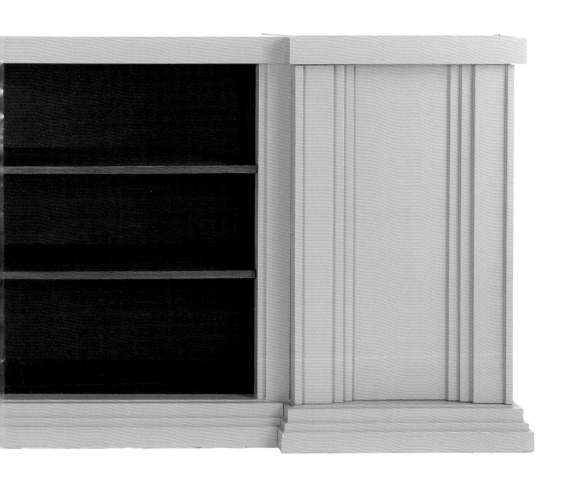

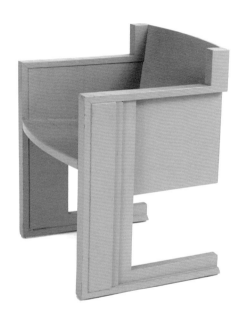
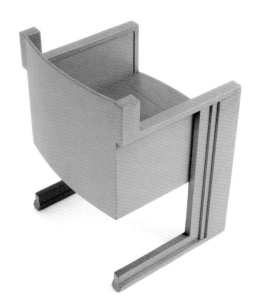

cantilevered armchair
Sachs apartment
1926-40
27"h x 21"w x 18"d

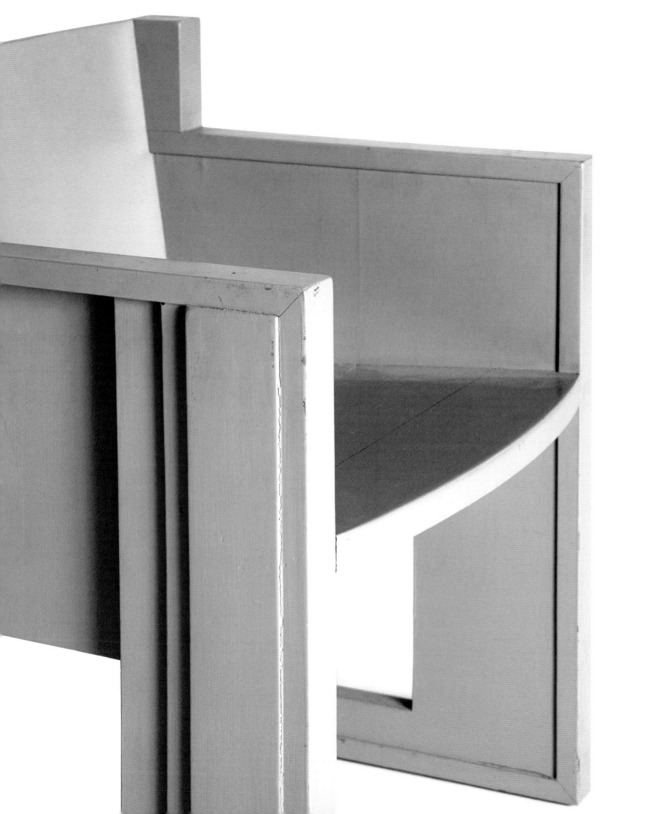

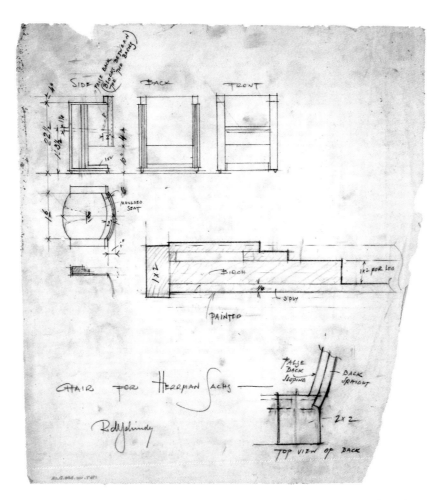

left cantilevered armchair (detail)
Sachs apartment
1926–40

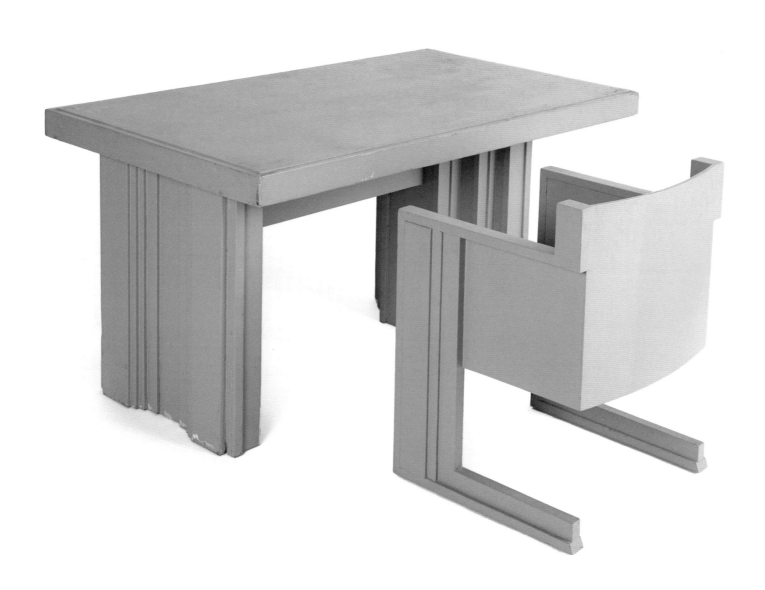

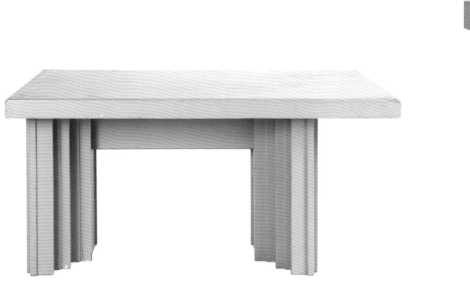
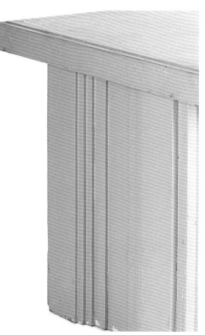

table
Sachs apartment
1926–40
26.5"h x 30.25"w x 54.25"l

85

pedestal
Sachs apartment
1926-40
26"h x 11.75" x 7.75"

William Stout Publishers
530 Greenwich Street
San Francisco, CA 94133
www.stoutpublishers.com
www.stoutbooks.com

Distributed in North America by
Ram Publications and Distribution
2525 Michigan Avenue, A2
Santa Monica, CA 90404
310.453.0043
rampub@gte.net

Library of Congress Control Number 2007939623
ISBN 978-0-9795508-2-9

Edited by Michael Boyd, Julie Cloutier, and Lis Evans
Photography by Steve Freihon
Images
page: 25 by Mario De Lopez
pages: 74 and 75 by Susan Einstein
pages: 40, 46, 51, 54, 55, 58, 59, 64, 65, 80
Photo courtesy Architecture & Design collection,
University Art Museum, University of California,
Santa Barbara
Design by Silvia Gaspardo Moro
with Progetto Immagine, Torino, and Michael Boyd

Printed in China